ZENSPIRATIONS
Flowers

CREATE, COLOR, PATTERN, PLAY!

Joanne Fink

DESIGN ORIGINALS
an Imprint of Fox Chapel Publishing
www.d-originals.com

Basic Patterns

Patterning is fun, easy and relaxing—and it's a great way to add interest and texture to your designs. The nice thing about patterning is that patterns don't need to be perfect, just rhythmic. In fact, most patterns are more interesting when they have subtle variations. To practice patterning, start by drawing a series of horizontal lines. The lines don't need to be totally straight or evenly spaced. By drawing lines different distances apart, you'll create some narrower spaces and some wider spaces in which to pattern, as in the example below.

After drawing your lines, look at the step-by-step examples below. Pick the one you want to do and start by drawing step one of that pattern between two lines. The illustration below shows step one of the "Four Lines & a Circle" pattern.

Next, starting at the beginning of the line, draw step two on top of step one as shown below.

Then, draw step three on top of step two as shown below.

Repeat this process for as many steps as you choose. Patterning is cumulative; each step adds detail to the previous step, and each one can be used as a stand-alone pattern. If you want a simple pattern, stop after one or two steps; if you want a very detailed pattern, keep adding steps. The more steps you do, the more complicated and impressive your finished piece will look!

Filler Patterns

Patterning dates back to ancient times. Medieval manuscripts are replete with patterns comprised of lines, dots and other small fillers. Try some of these designs, or create your own filler patterns.

Triangle Pattern Variations

There are many ways to decorate a simple triangle pattern; here are some examples. I encourage you to experiment and try creating new patterns all your own.

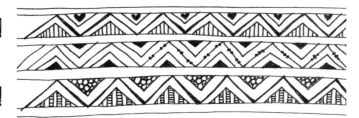

Patterns: Step by Step Examples

Four Lines & a Circle Pattern

step one | step two | step three | step four

Loop Pattern

Arch Pattern

step one | step two | step three | step four | step five | step six

Triangle Pattern

step one | step two | step three | step four | step five

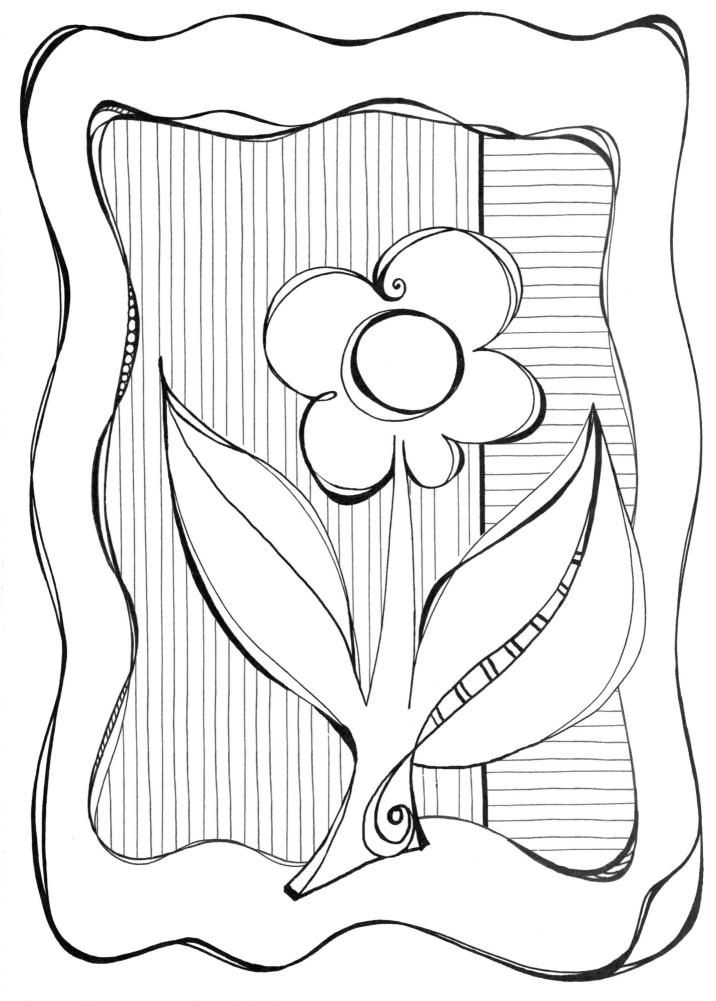

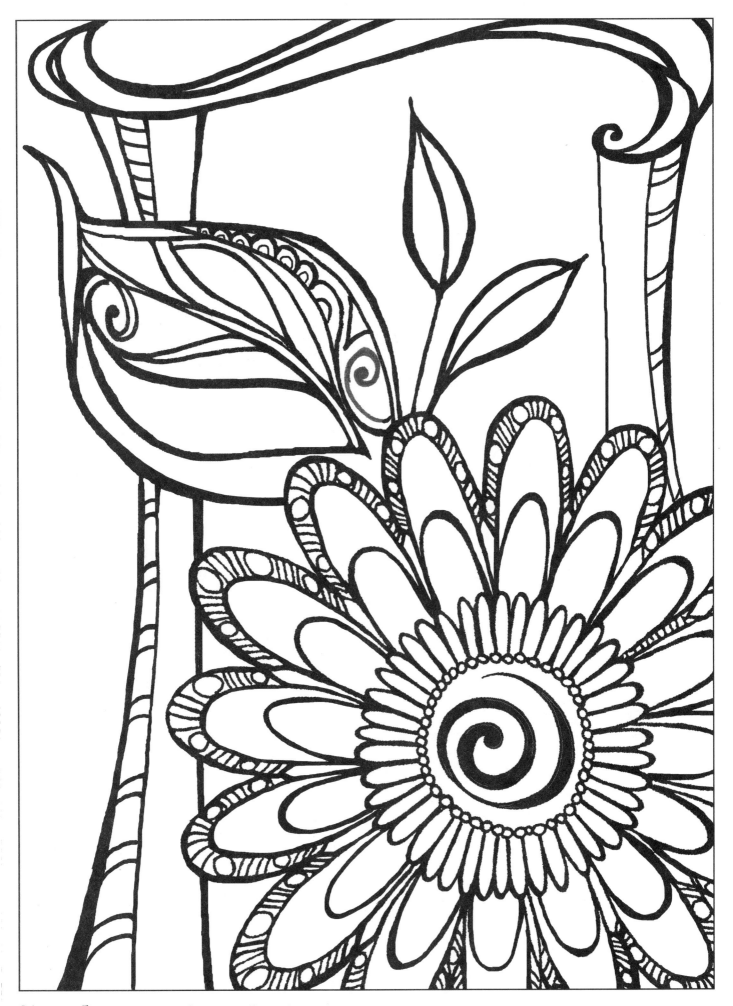

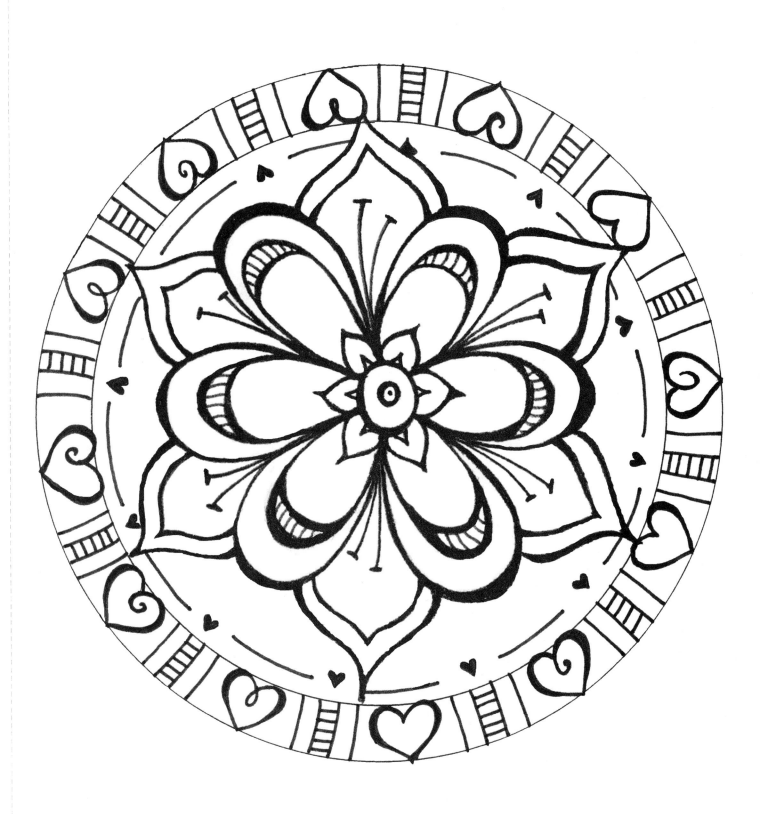

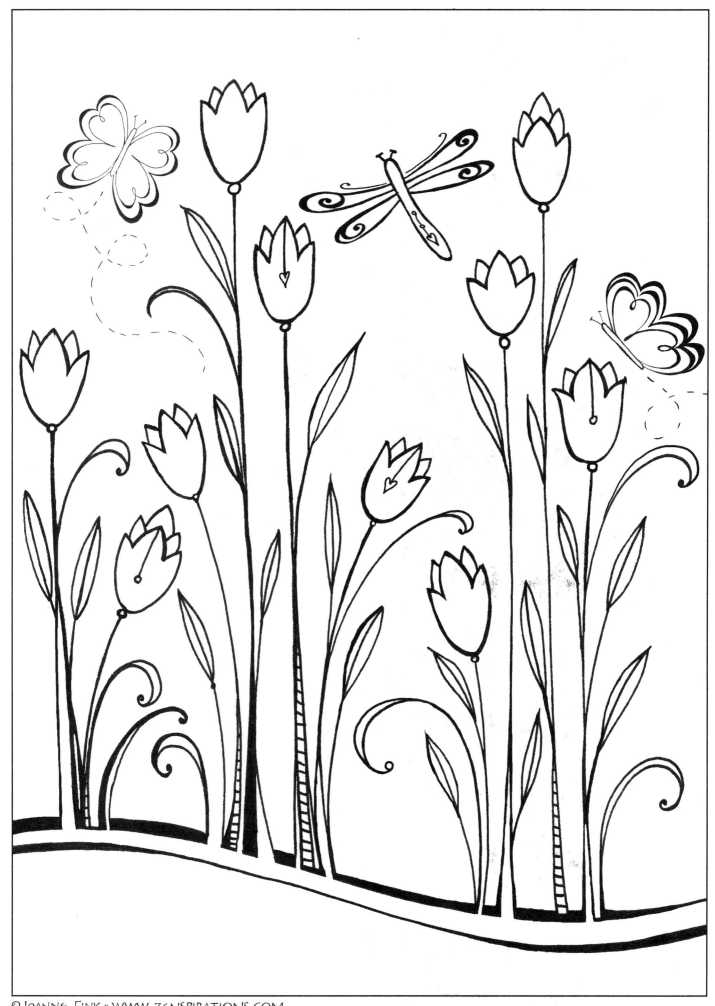

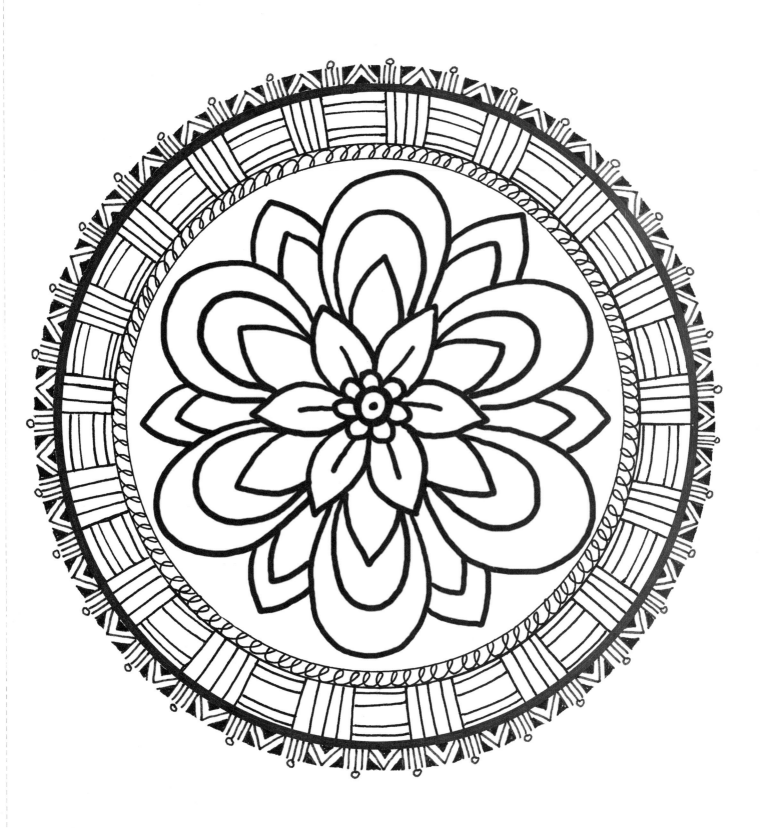

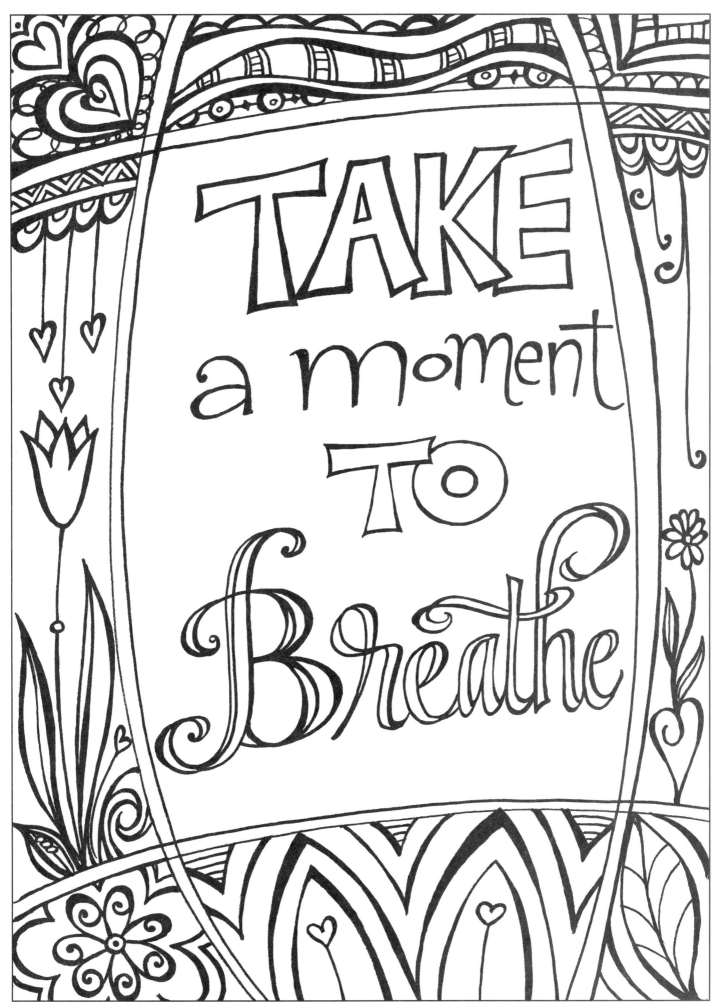

TAKE a moment TO Breathe

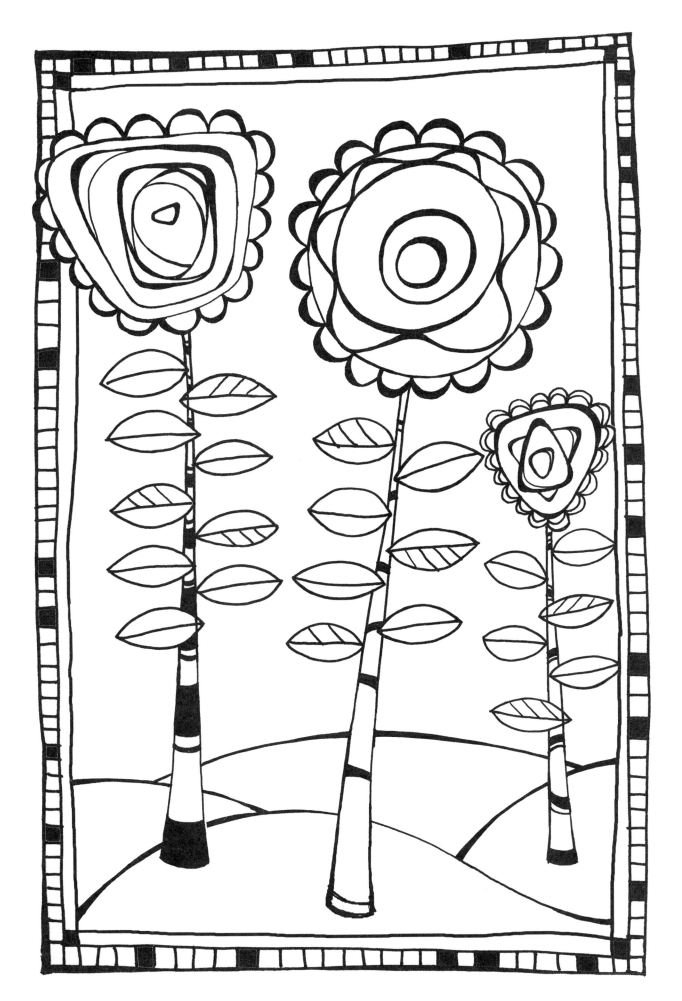

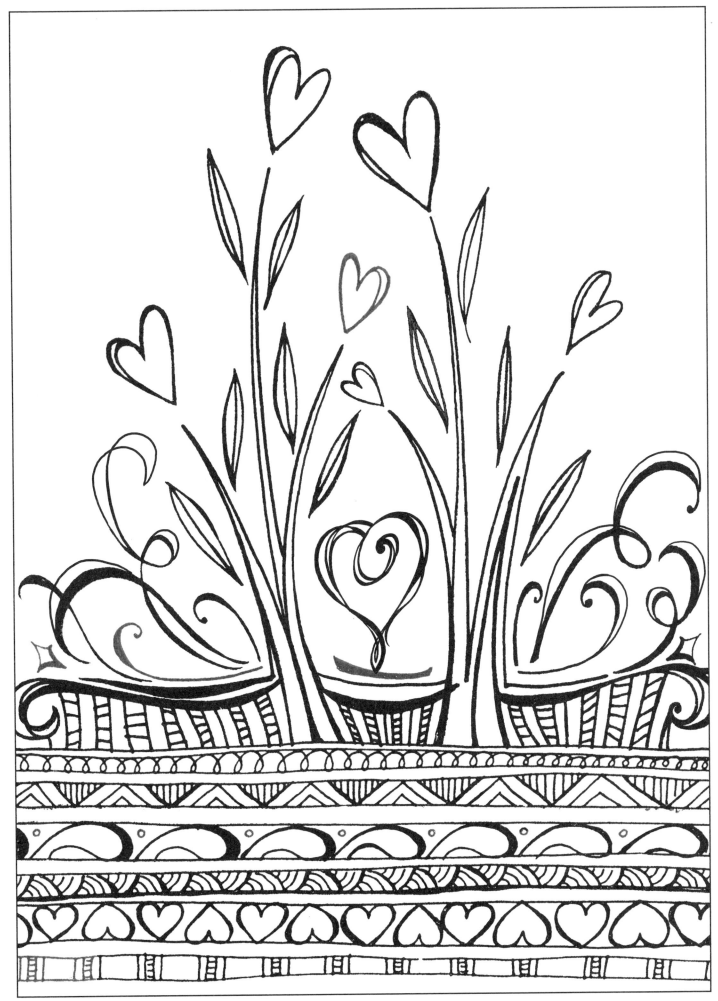

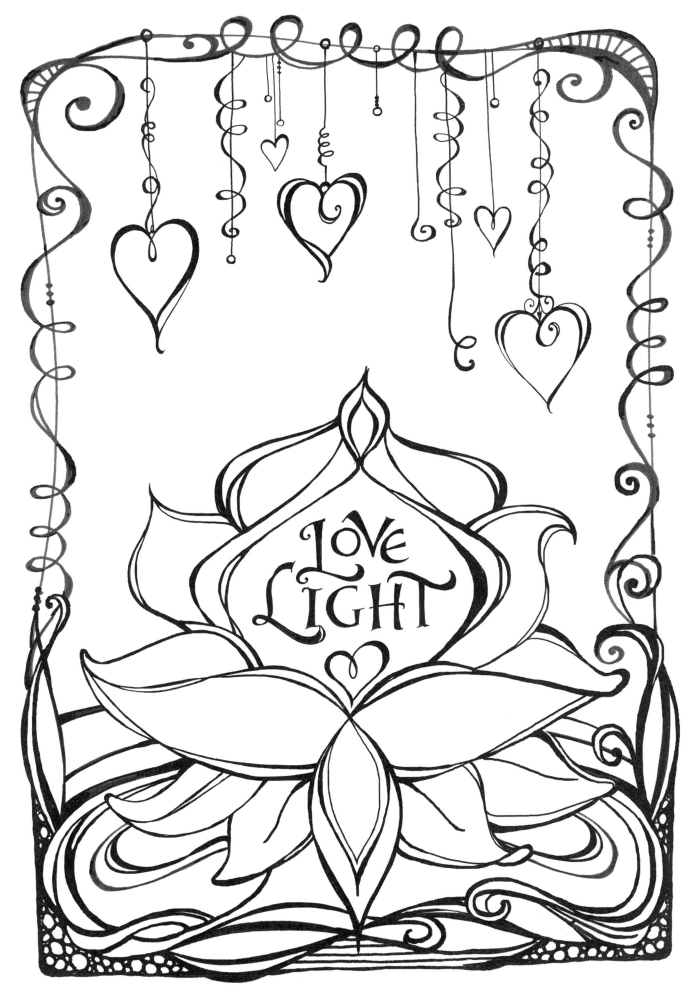

LOVE LIGHT

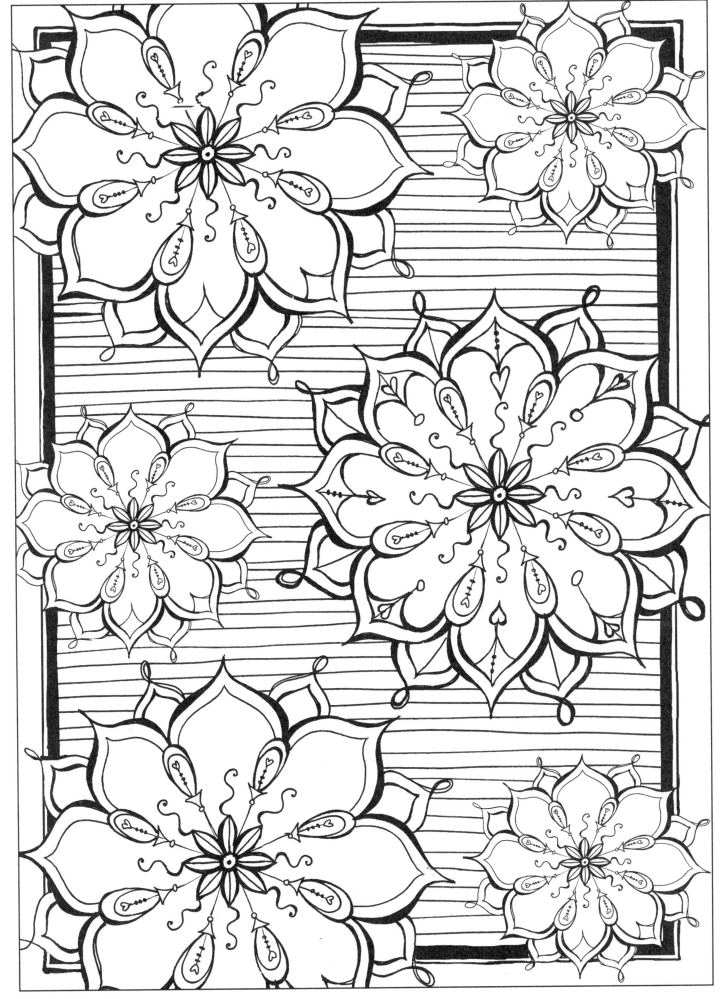

©JOANNE FINK ˖ WWW.ZENSPIRATIONS.COM

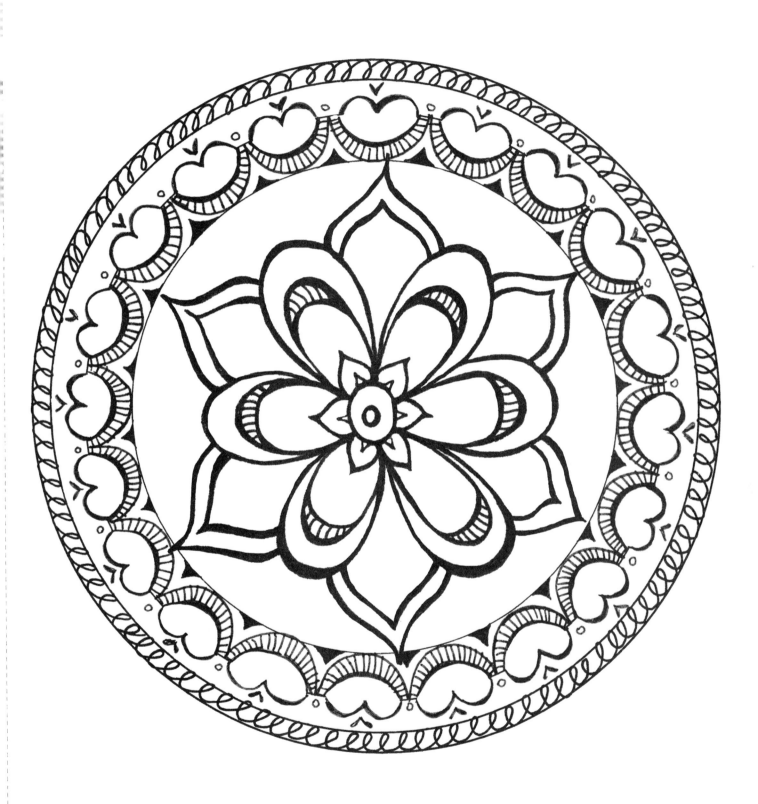

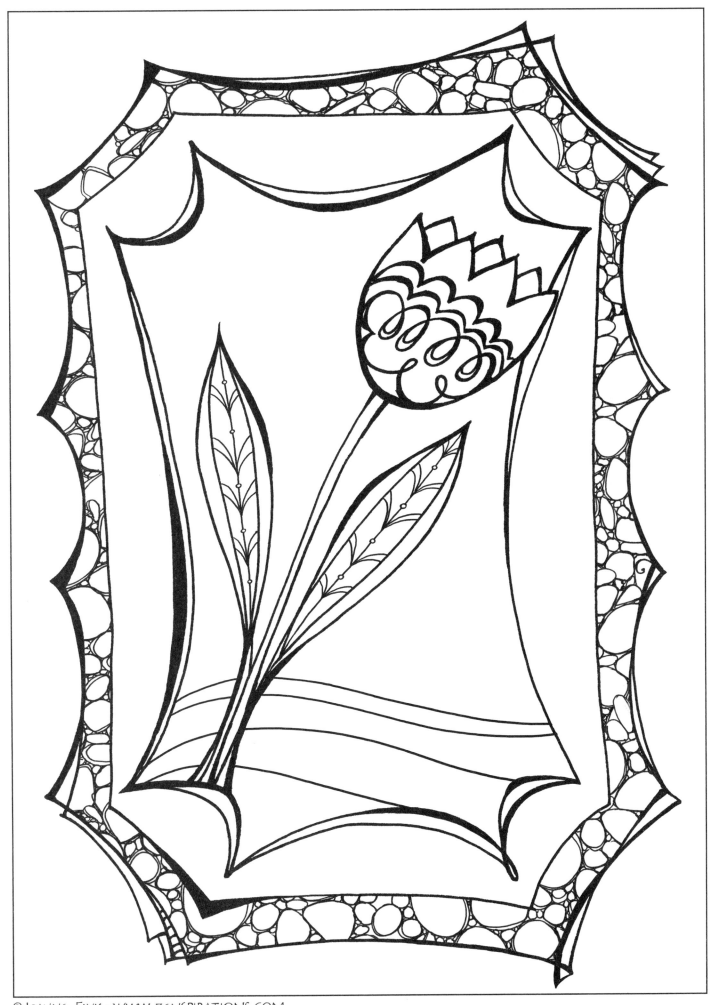

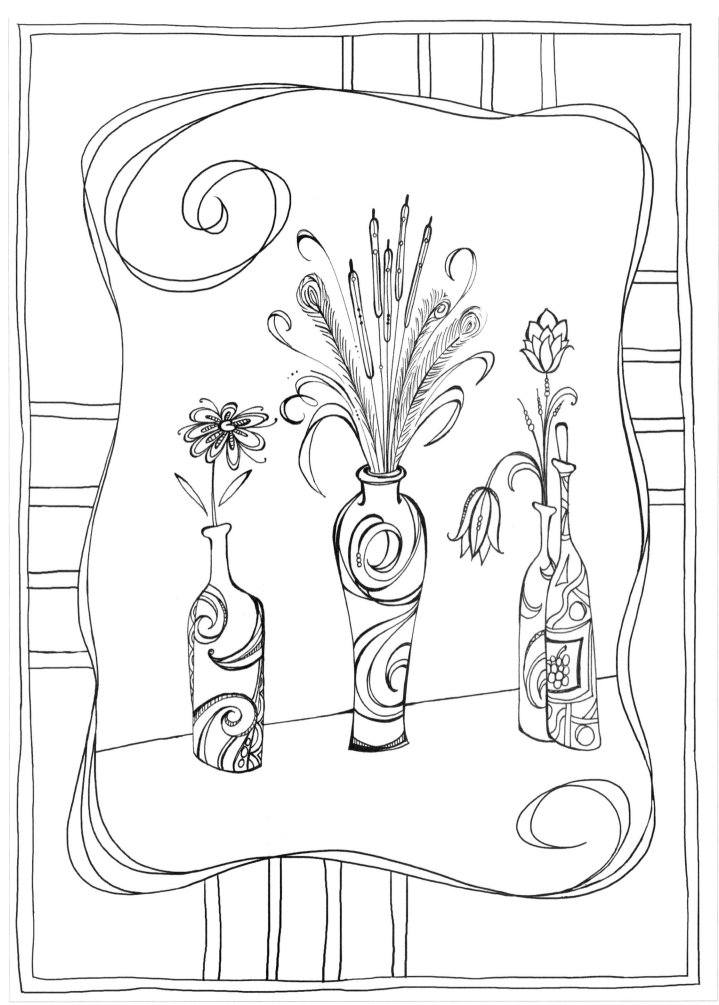

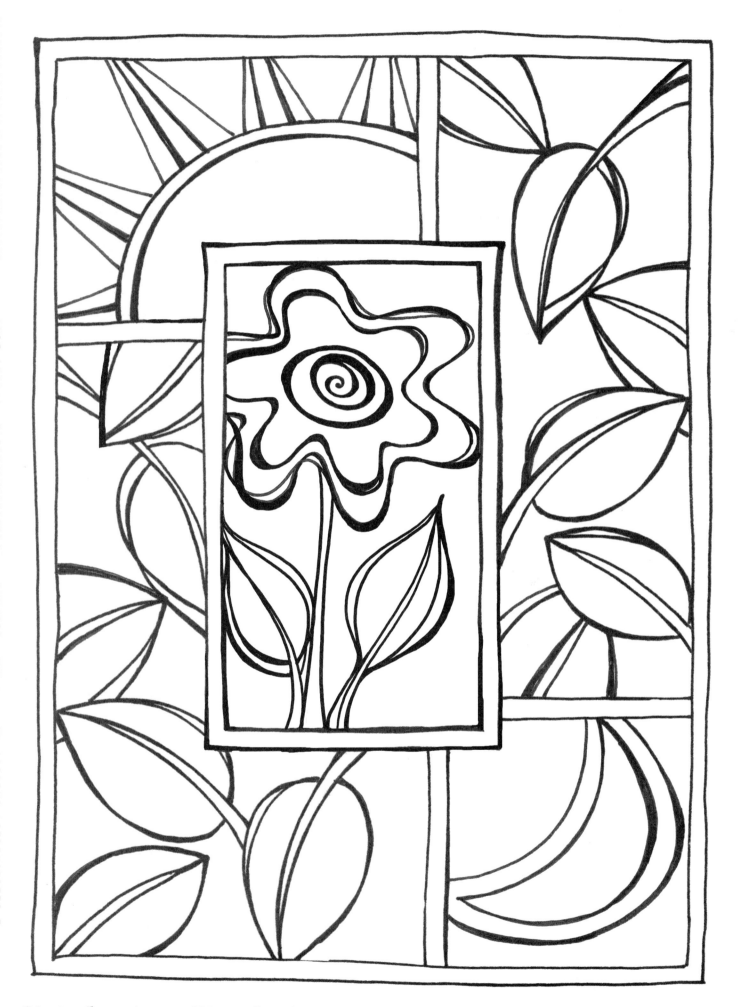

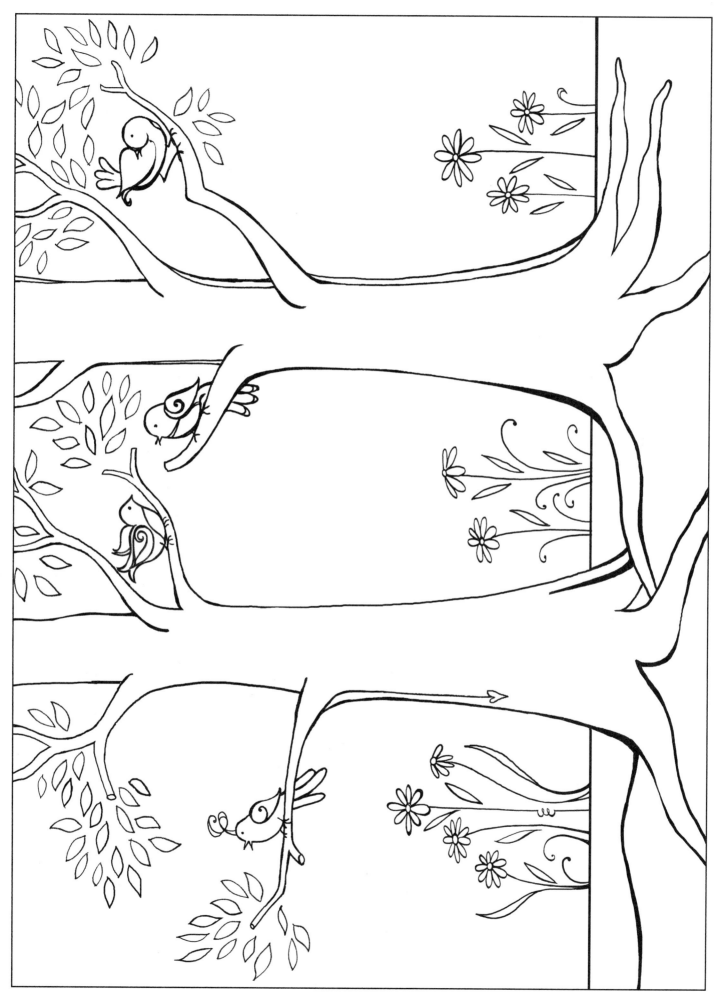

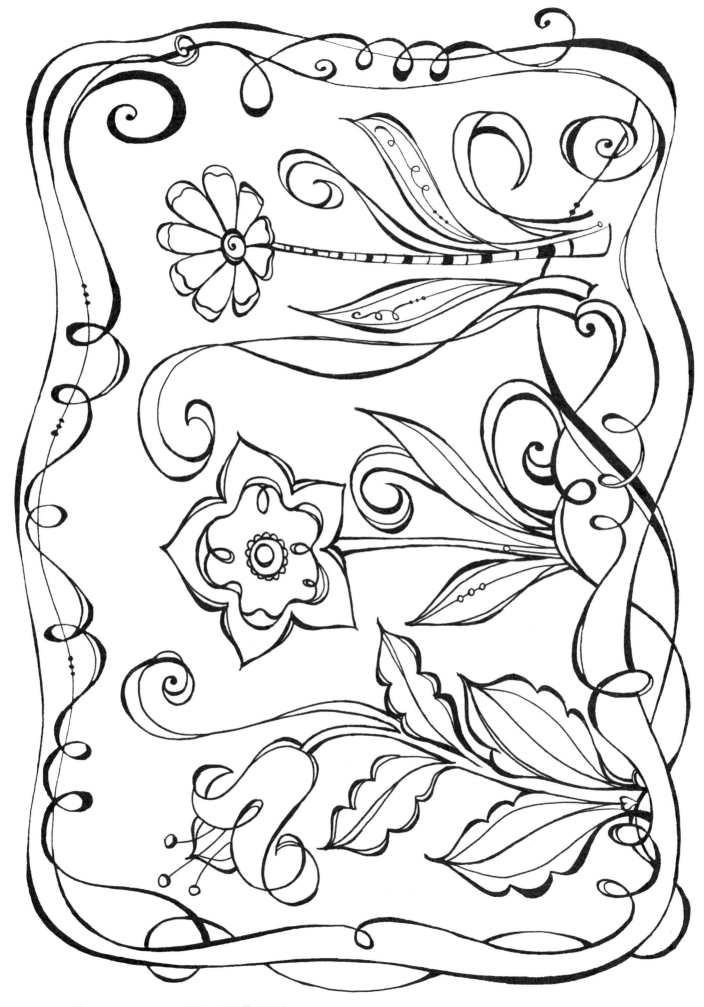

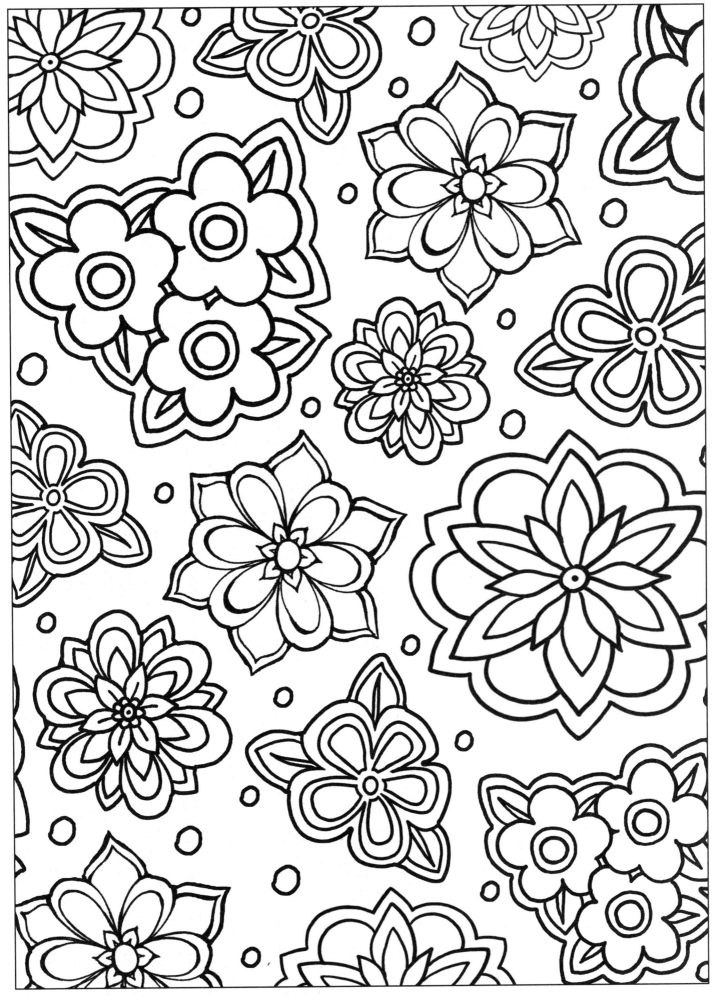

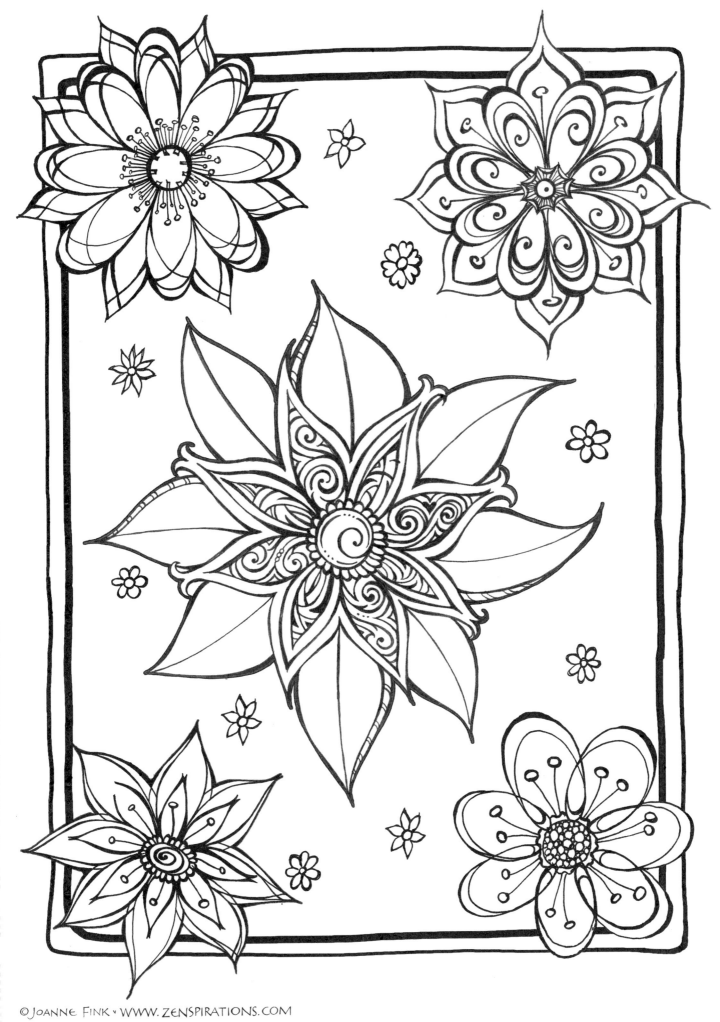

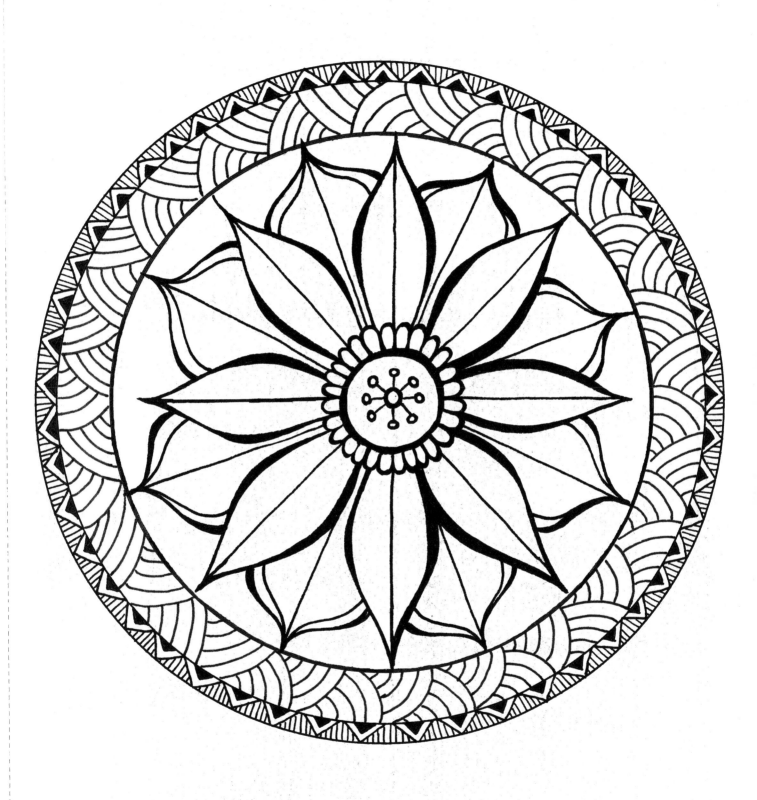

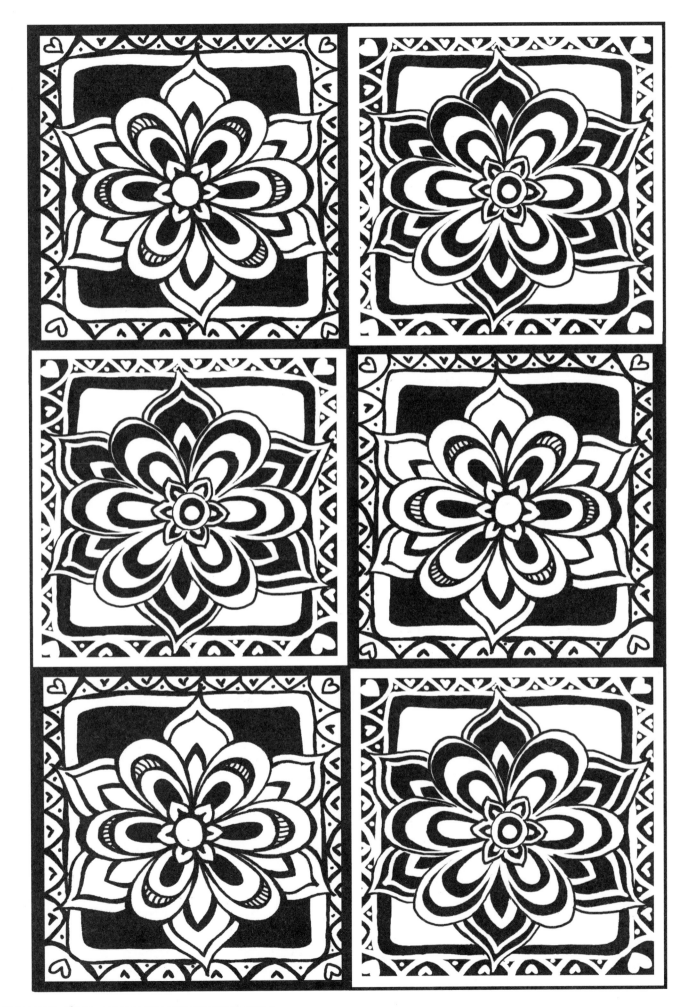

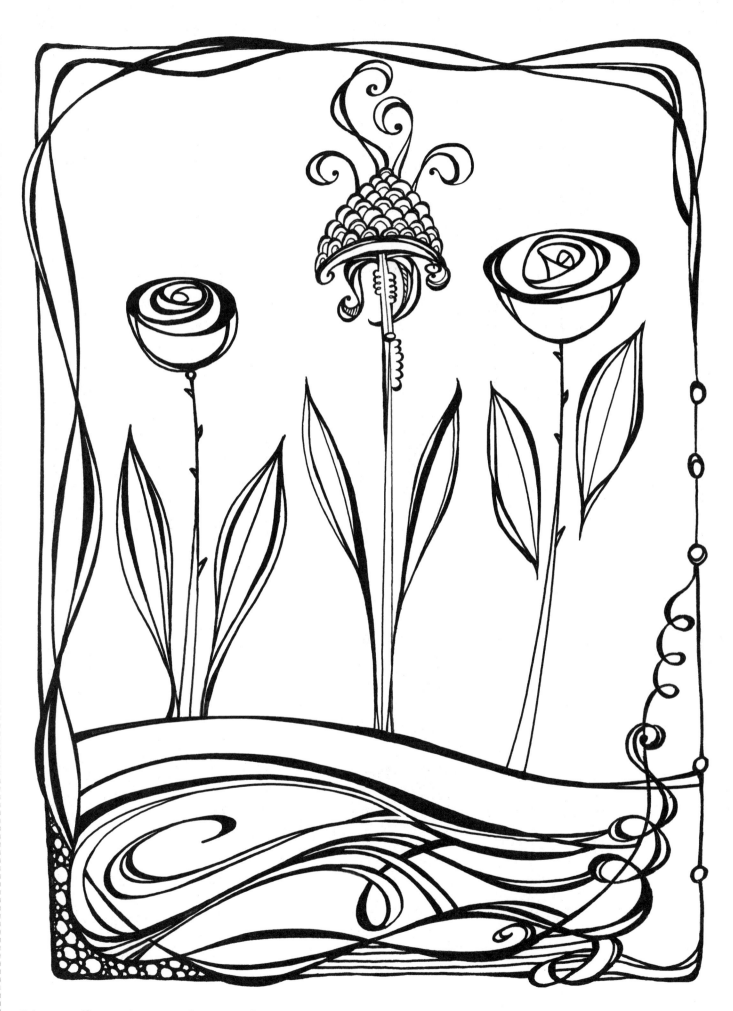

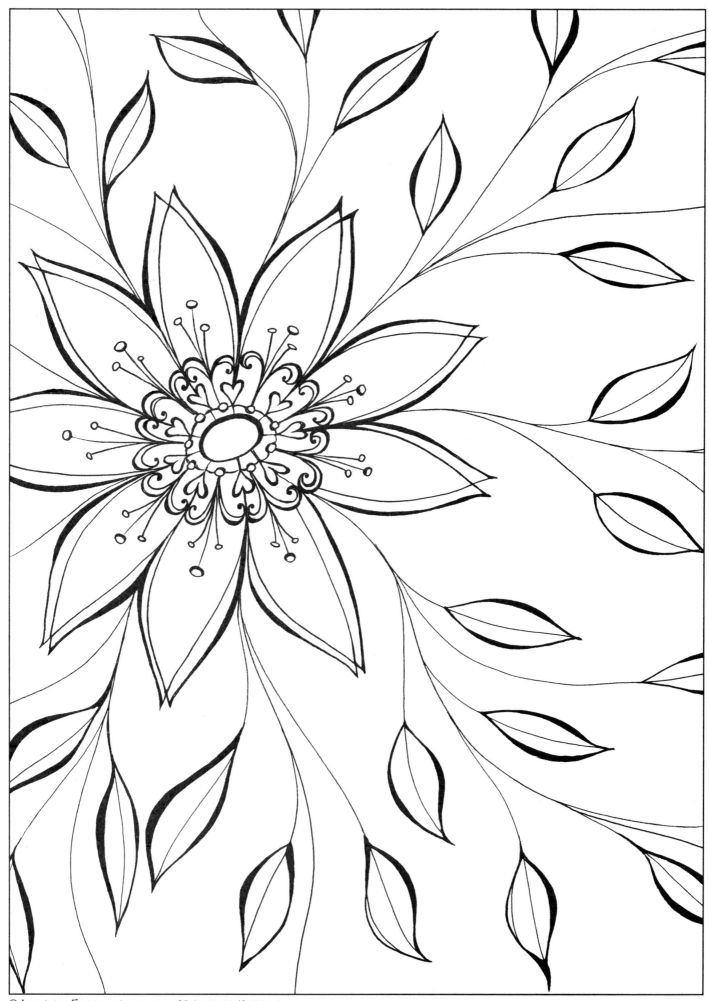

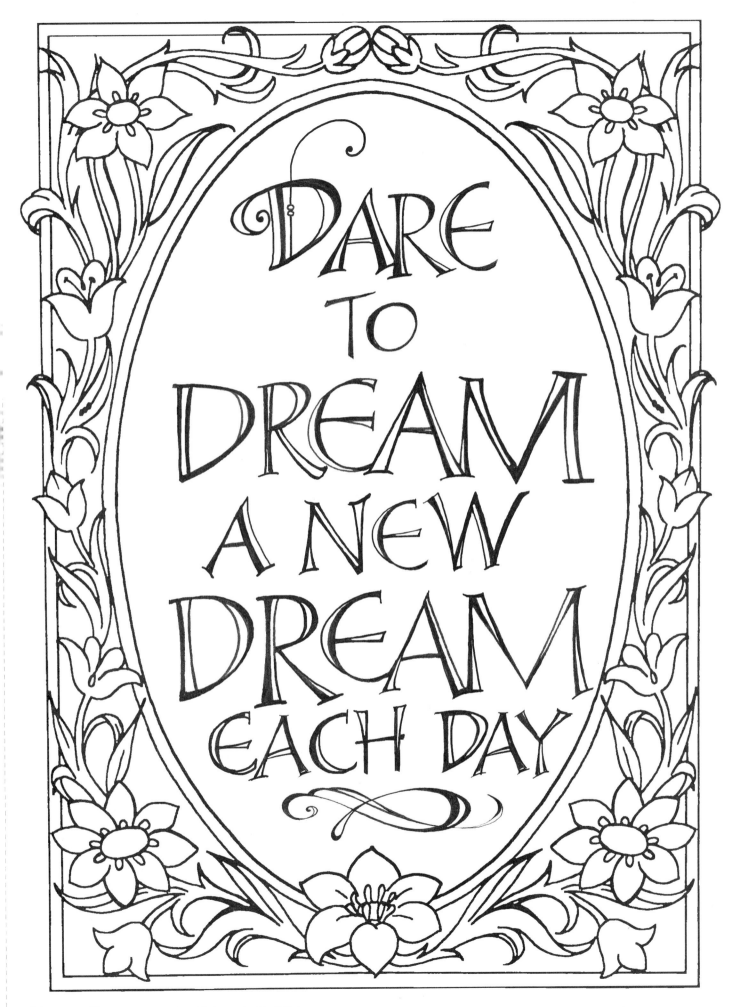

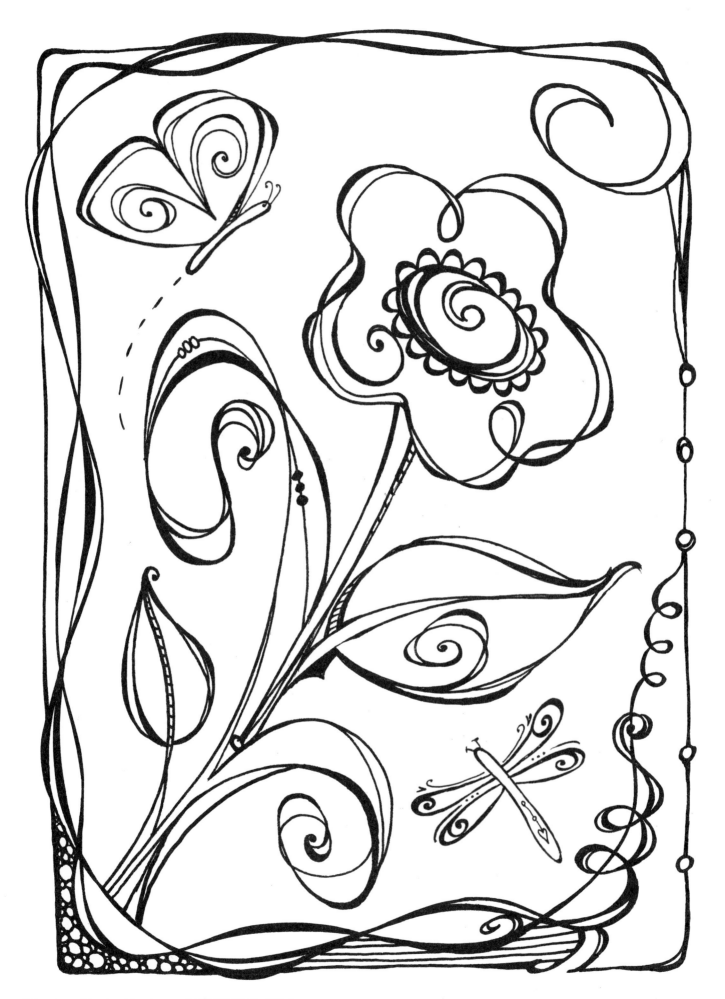

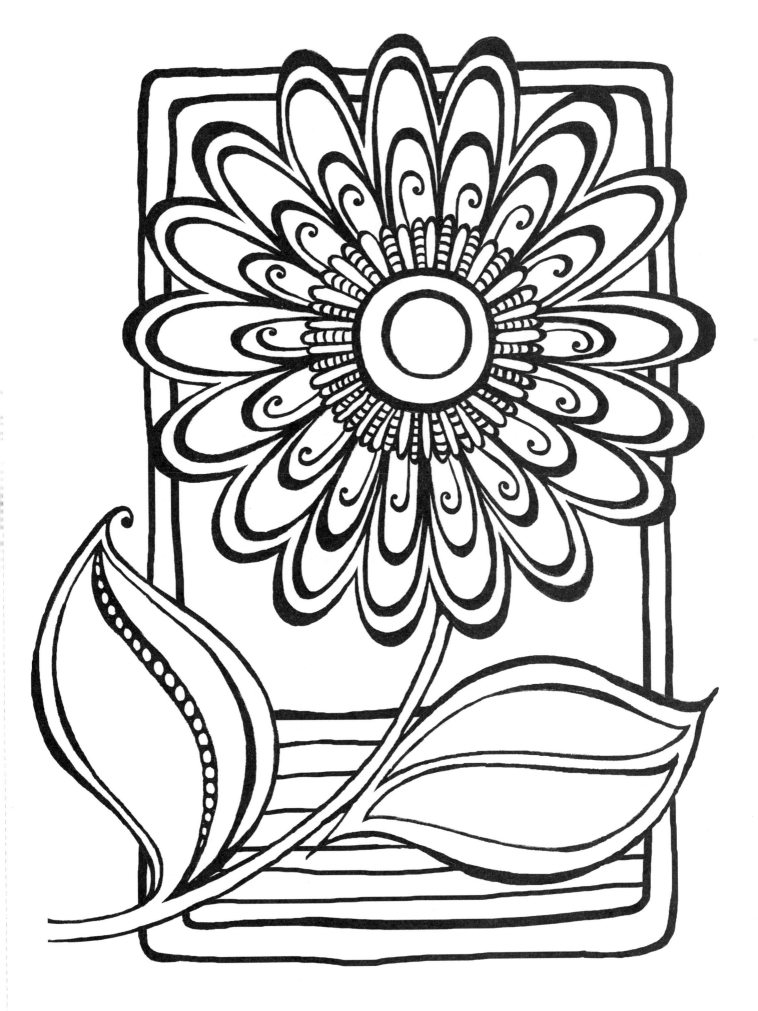

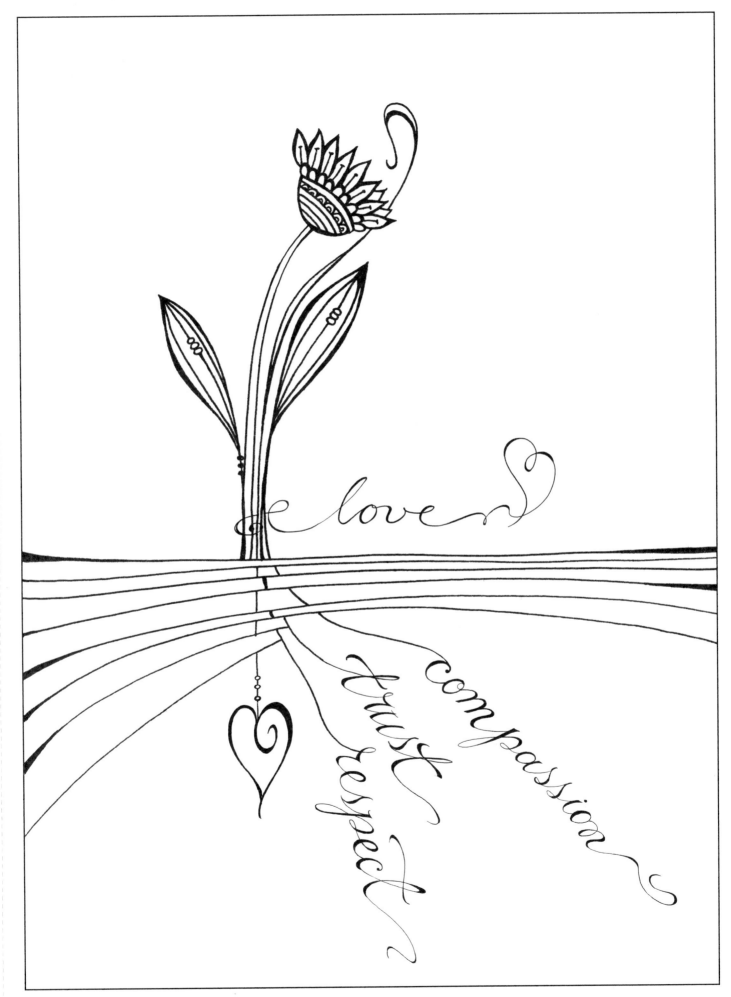

love

compassion

trust

respect

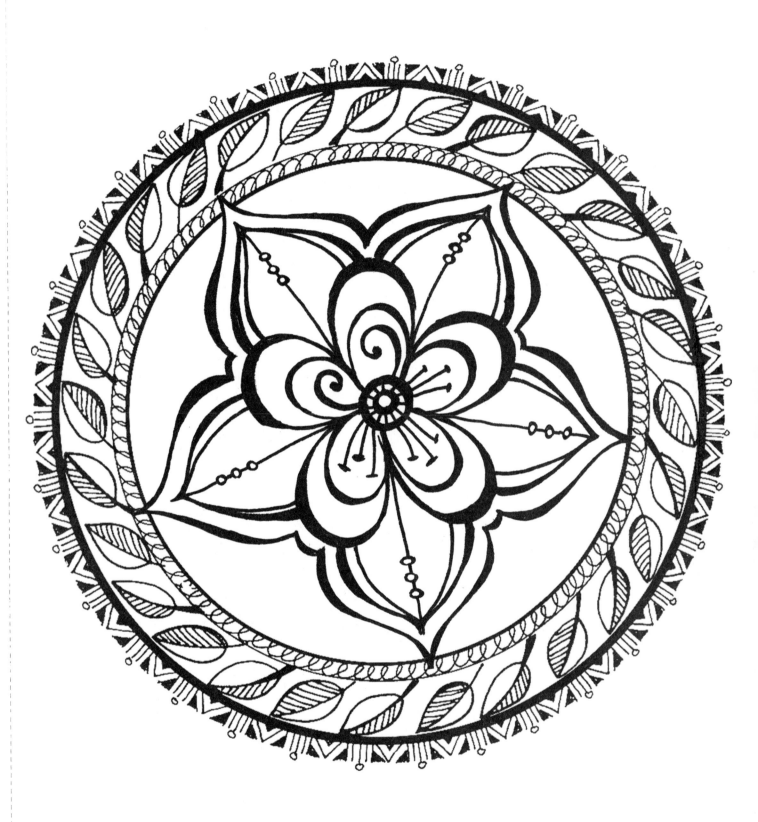

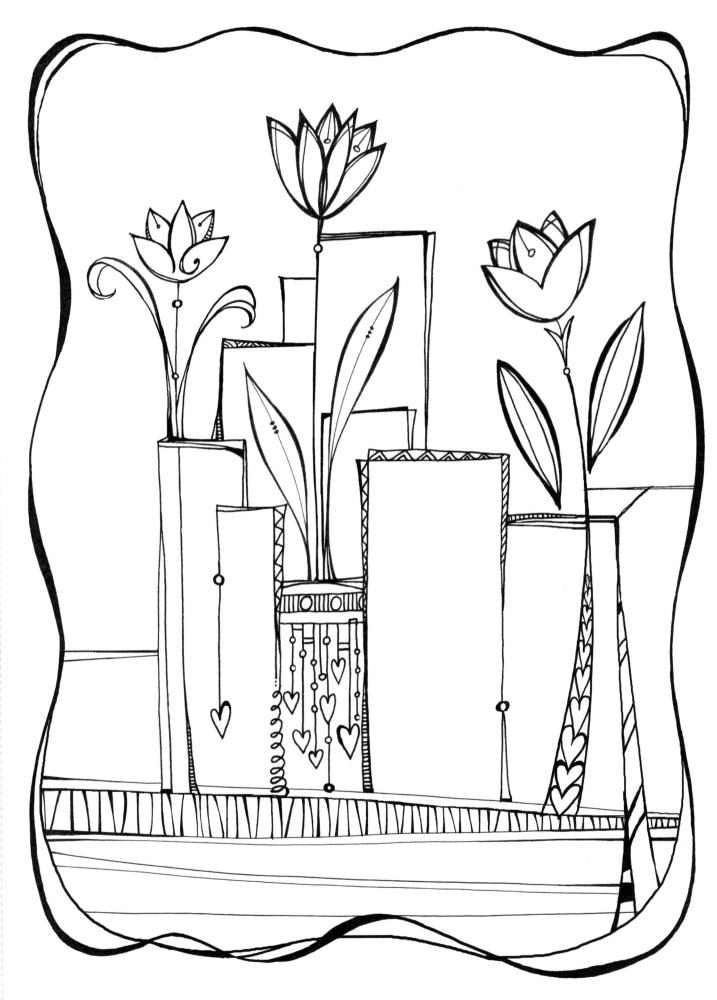

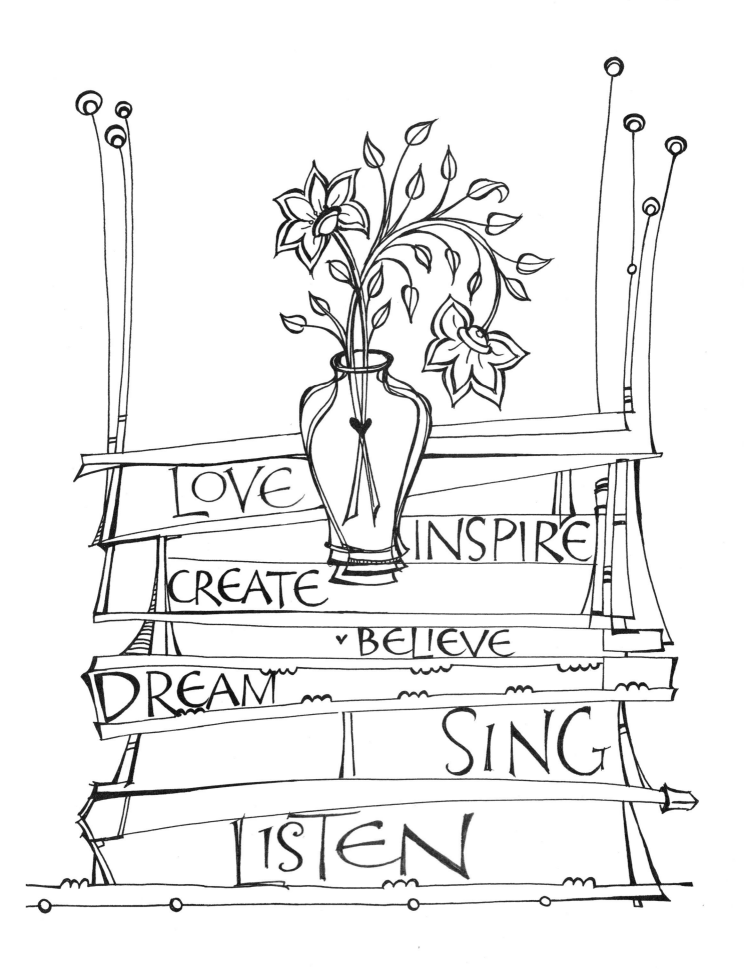

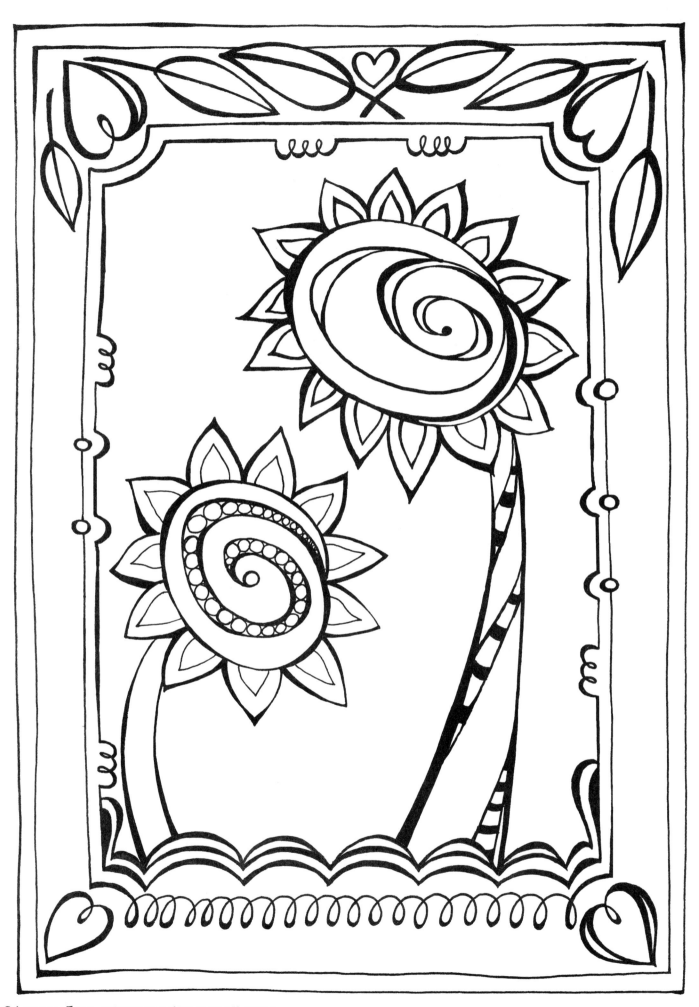